C. Pissarro

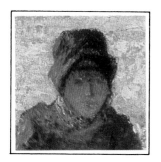

THE LIFE AND WORKS OF

PISSARRO

Linda Doeser

A Compilation of Works from the
BRIDGEMAN ART LIBRARY

||| •PARRAGON• |||

Pissaro

This edition first published in Great Britain in 1994
by Parragon Book Service Limited

© 1994 Parragon Book Service Limited

ISBN 1 85813 621 0

Printed in Italy

Editor: Alexa Stace
Designer: Robert Mathias

The publishers would like to thank Joanna Hartley
at the Bridgeman Art Library for her invaluable help

CAMILLE PISSARRO 1830-1903

C. Pissarro

CAMILLE PISSARRO was born on 10 July, 1830 on the island of St Thomas in the Caribbean. His father, Abraham Gabriel Pissarro, was a French Jew of Portuguese origin who owned a hardware business in the port of Charlotte-Amalie. His mother, Raquel Manzano, was Creole.

He showed an early talent for drawing, but this was not encouraged by his parents, who had planned a career for him as a businessman. In 1841, he was sent to Paris to further his education. He lived in a boarding-house in Passy, where the owner, Savary, encouraged his drawing and suggested that he should draw out-doors, observing nature at first-hand – an almost unheard-of practice at this time.

Pissarro was recalled to St Thomas at the age of 17, to work as a commercial employee. In 1850, the Danish painter Fritz Melbye was sent there on government business. Intrigued by the young man who snatched every opportunity to sketch and draw, the two soon became friends. Melbye encouraged his artistic aspirations and Pissarro eventually decided to accompany his new friend on his mission to Venezuela.

Pissarro returned to St Thomas in August 1854, but within a year he had left for France: his father had recognized that his son's talent could not be suppressed. Once in Paris, Pissarro attended various courses, possibly even some at the École des Beaux-Arts. He worked hard at academic painting, but his instincts led him towards landscape, nature and first-hand observation.

He was a great admirer of Camille Corot, famous for his subtle and elegant landscapes, and when Pissarro first submitted his work for exhibition, he described himself as a 'pupil of Corot'.

A meeting that was to have long-term importance in Pissarro's life and a profound effect on the direction in which late 19th-century art would move took place in 1857. While he was attending the Académie Suisse, an informal studio, he met the 17-year-old Claude Monet. He came from a similar bourgeois background and this, combined with shared tastes and temperaments, nurtured a friendship.

Pissarro's first Salon picture, *Landscape at Montmorency,* was exhibited in 1859, but the paintings he submitted in 1861 and 1863 were rejected. Pissarro's work reappeared in the subsequent Salons of 1865, 1866 and 1868 and received some favourable comment in the press.

The clarity and luminosity that would characterize the work of all the Impressionists began to make an appearance in Pissarro's paintings. His confidence in manipulating paint grew, particularly now that he was working with a palette knife. He moved out of central Paris to be closer to the sources of his inspiration in the northern French countryside, and settled in Pontoise with his mistress Julie Vellay. The couple already had two children but it was to be some years before they married.

In Paris, the café Guerbois was a meeting-place for artists and intellectuals and here Pissarro encountered such figures as Manet, Degas, Renoir, Fantin-Latour, Duranty, Zacharie Astruc and Emile Zola.

In 1869 Pissarro and his family moved to Louveciennes, but by 1870 a German invasion of France seemed inevitable. Pissarro fled the Franco-Prussian War, first to Brittany, and then to England. Monet had also taken refuge in England and Pissarro's friendship with him flourished. In London he met Durand-Ruel, a French art dealer who bought some of Pissarro's work, for which the artist was very grateful as he was having little success in England.

Pissarro and Julie Vellay were married in 1870 and returned to Louveciennes the following year. Here, he discovered that all the paintings he had left in his studio – some 1,500 – had disappeared. Many had been destroyed, some even being used as duckboards in the garden. Far from being despondent, Pissarro seems to have regarded this as a kind of liberation. The loss of his early work offered the chance for a bold new start, in spite of him now being in his 40s.

He and his family moved to the Hermitage quarter of Pontoise, and he returned to the familiar landscapes that he loved – something that he would continue to do throughout his life. He also travelled further afield to Osny and Auvers, where Cézanne was then working. The two men had first met in 1861 and now warmly renewed their friendship and there is little doubt that they influenced each other's work at this time.

By 1874 Pissarro was regarded as the senior member of a group of artists – Monet, Cézanne, Guillaumin, Renoir and Sisley – who were dissatisfied with the rigidity of the Salon. They organized an exhibition of their own, but were totally unprepared for the fireworks that followed. The press and public poured forth a vitriolic stream of scorn and ridicule. The paintings were considered outrageous, not for their subject matter, but for the technique used. In particular, Monet's *Impression, Rising Sun* provoked much harsh abuse. The term 'Impressionism' was coined in an article ridiculing this work. The word quickly caught on and was adopted by the artists themselves.

Two more exhibitions were held in 1876 and 1877, at the Durand-Ruel gallery. Only those prepared to admit to the infamous name of Impressionism were accepted. At the third exhibition there were 18 exhibitors, including Sisley, Monet, Degas, Renoir, Berthe Morisot, Cézanne and Pissarro – a galaxy of the stars of Impressionism. All these painters had a strong streak of individualism but Pissarro stood out as their acknowledged leader.

While Pissarro was slowly achieving recognition, he was far from financially secure. Seven children were born between 1863 and 1884 and Pissarro was very conscious of his parental responsibilities. Letters dating from this period reveal the seriousness of his financial problems and his awareness of them, yet his work never reflects sadness, let alone despair.

By the early 1880s Durand-Ruel was encountering hard times and this inevitably had a dire effect on the artists that he had championed. Nevertheless, he set about organizing a series of one-man shows; Pissarro's took place in May 1883. Business began to pick up again and a healthy overseas market, particularly in London and in the United

States, developed. Pissarro moved to Eragny-sur-Epte in 1884 and the house there remained a family home until his death.

In 1885, Pissarro was introduced to Georges Seurat, who was developing the style of painting known as Pointillism or Divisionism. Always open-minded, Pissarro became convinced that this technique would add greater luminosity to the painted surface. A radical change in style was a bold step for an artist in his late 50s: his experiments with Pointillism did not meet with universal approval and eventually he came to the conclusion that it was a sterile technique that lacked the spontaneity and immediacy that he valued in art.

The last decade of the 19th century saw major improvements in Pissarro's fortunes. His former supporters, including Durand-Ruel, relieved by his abandonment of Neo-Impressionism and the Pointillist technique, renewed their allegiance. Two landscapes were sold for quite substantial sums at auction in May 1890. Even more gratifying was the growing recognition of Pissarro as a master of Impressionism. In 1890, Theo van Gogh, Vincent's brother, organized a one-man show of Pissarro's work and Durand-Ruel held regular exhibitions from 1892 to 1901.

Pissarro made a number of visits to England, Belgium and Holland during these years and travelled widely in northern France. He developed an interest in etching and, in fact, continued to work on engravings up to the day before his death. In 1895 he developed an eye disease, which caused his sight to deteriorate and forced him to work indoors. Consequently, many of his later paintings, especially the cityscapes of Rouen and Paris, were viewed through windows.

Pissarro died in November 1903, leaving behind a rich legacy of paintings, etchings and lithographs. A great painter himself, this kind and gentle man had had a powerful influence on the other artists of his time. Cézanne described him as ' humble and colossal' – a fitting epitaph.

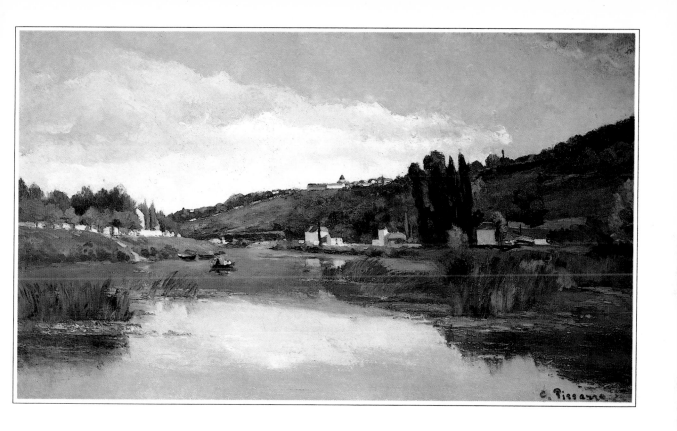

△ **Banks of the Marne et Chennèvieres** 1864-5

Oil

PISSARRO'S ADMIRATION for Corot and the older artist's influence are still apparent in this work. Pissarro's instinct was to paint landscapes and he was wisely advised by Corot to observe them at first hand – an unusual practice in those days. The author Emile Zola described Pissarro at about this time as having 'the arrogant clumsiness to paint solidly and to study nature frankly' and 'an extreme concern for truth and accuracy'. However, even this early in his career, Pissarro was fascinated by the quality and vibrancy of light – a direction he was to pursue unflinchingly throughout his life.

▷ **La Route de Louveciennes** 1870

Oil

PISSARRO LIVED in the town of Louveciennes in the late 1860s – a period of intense technical experimentation. His inspiration remained the local landscapes – La Varenne, Pontoise, Montmorency and, from 1869, Louveciennes. By now, the influence of Corot had largely faded, and 1870 could be regarded as the end of Pissarro's 'apprenticeship'.

Looking back on this period, he was later to say that even at the age of 40, he did not have any idea of the nature of the artistic movement that he and his friends pursued so instinctively. It was, he said 'the air'. Indeed, this painting, like many that would follow, has an atmospheric quality that makes the intangible almost possible to touch.

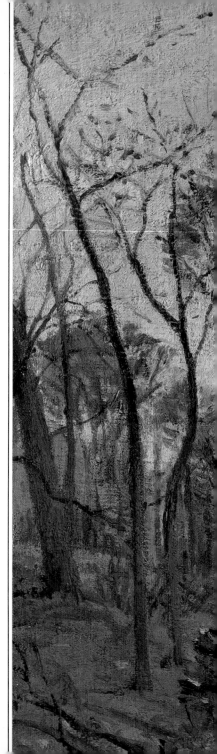

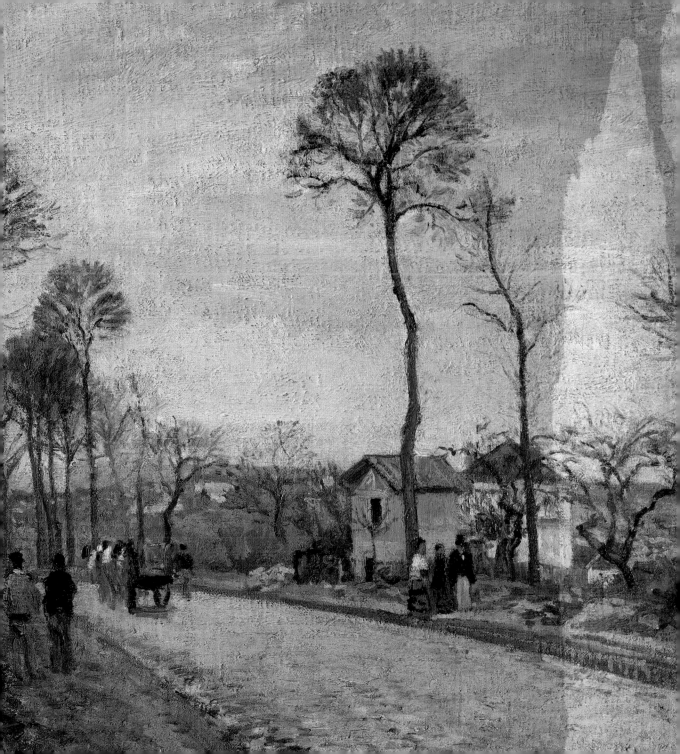

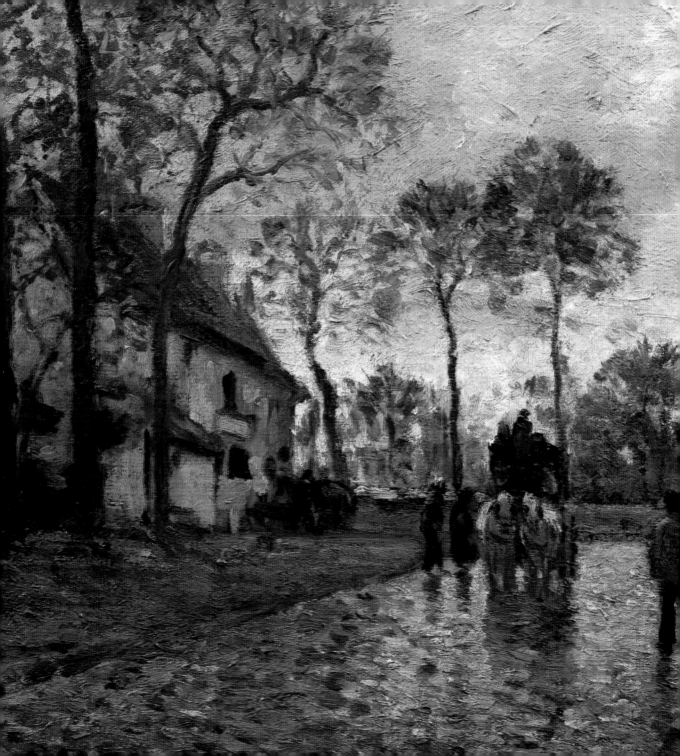

◁ **The Diligence at Louveciennes** 1870

Oil

EVEN BEFORE PISSARRO, Monet and other fellow-painters had fully developed the theory and technique of what was to become Impressionism, Pissarro's work had a freshness and spontaneity that sprung from capturing what was, in effect, his first impression of a scene. The subtle luminosity, the reflections and shadows, the casual passers-by and the very movement of the trees have all been acutely observed. By this stage in his career, Pissarro was showing a confidence and maturity in his work, although he never stopped experimenting throughout his long life.

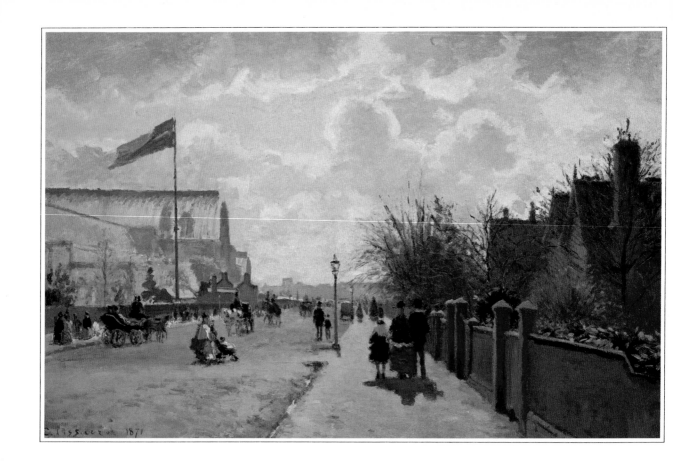

△ **The Crystal Palace, London** 1871

Oil

PISSARRO TOOK REFUGE in London when a German invasion of France seemed imminent in 1870. He hated England and was desperately homesick. His work was scorned and, in general, he was not accepted by the other artists of the city. However, he produced some fine paintings during this dismal period – when his thoughts and approach to what was to become Impressionism were beginning to gel. There is a clarity and luminosity in this painting of a London scene that had not appeared in Pissarro's earlier works. It has simplicity and truth, and is completely devoid of any feeling of drama. Perhaps this unfashionable approach explains why Pissarro met with such little appreciation from English painters and, in particular, critics.

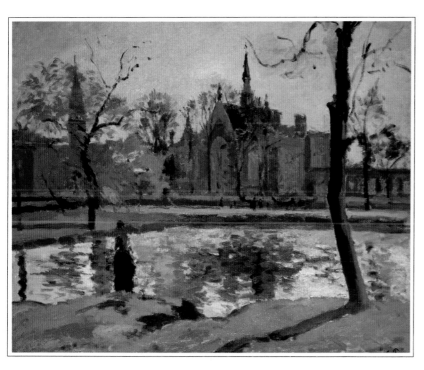

◁ **Dulwich College, London**
1871

Oil

THE FRESH IMMEDIACY of
Pissarro's rendering of
reflected light, the silhouetted
figure, the use of primary
colours and the sheer
Impressionism of this painting,
for there is no other word to
describe it, shocked the
outraged London art world,
which was used to precise,
naturalistic renderings of
landscapes and city scenes.

▷ **Hillside of Vesinet,
Yvelines** 1871

Oil

EVERY NOW AND THEN, Pissarro
seems to have taken special
delight in his sheer technical
virtuosity in depicting vast
panoramic landscapes. This
painting is a typical example,
the countryside stretching
away far into the distance. Yet
for all its grandness of scale,
the subject still has the
simplicity we associate with
Pissarro's rural scenes. He
developed a deep affection for
the countryside of northern
France, betrayed by his close
observation of everything he
painted.

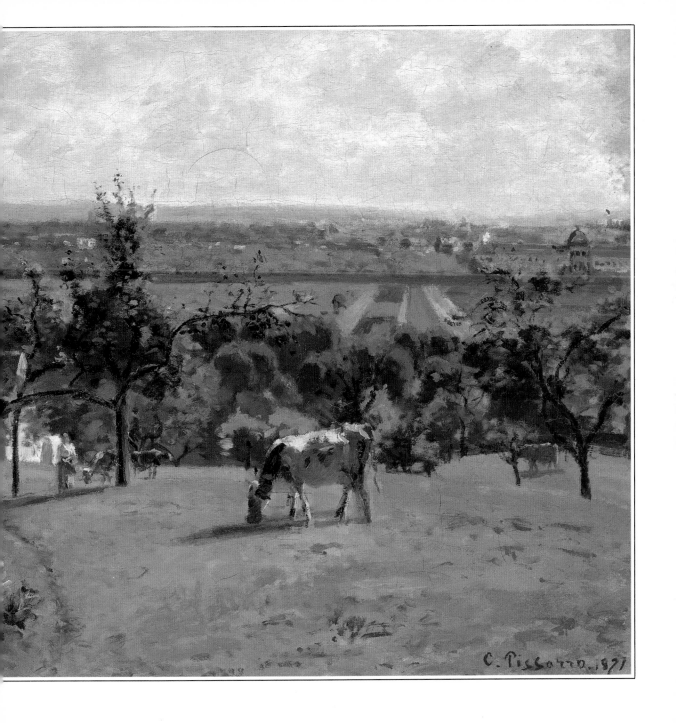

C. Pissarro. 1871

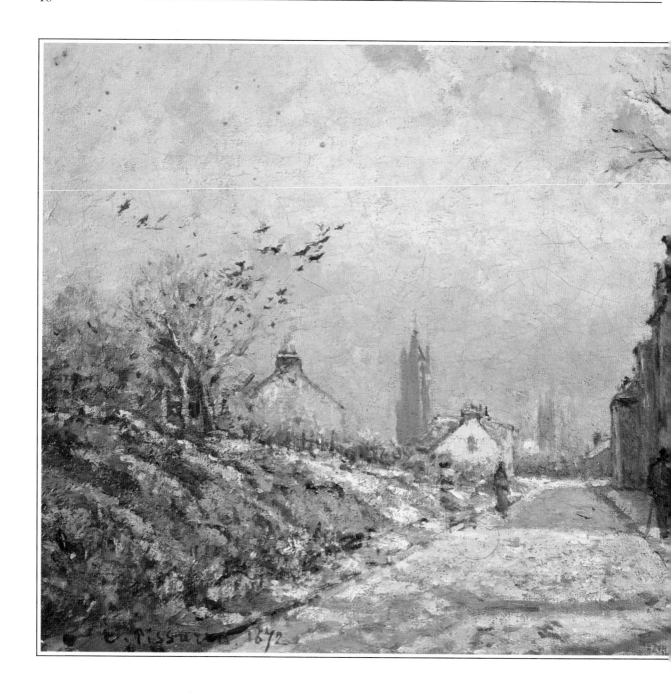

◁ **La Route, Effet d'Hiver (The Road, an Impression of Winter)** 1872

Oil

FAR FROM FEELING defeated that all his earlier work had disappeared, Pissarro looked boldly forward to the future when he returned to France. He moved to Pontoise and sought the inspiration of familiar landscapes and villages. By this time, however, he was painting in a style that is identifiable as truly Impressionistic. Here, he has precisely captured the quintessence of winter: the heavy-laden sky, the hardened earth, the pale sunshine and even a sense of cold. It is difficult to suppress a shiver when looking at this painting, and the ears strain to catch the sounds of the wheeling birds.

▷ **Impression of Winter: Carriage on a Country Road** 1872

Oil

THE INFLUENCE of Claude Monet is apparent in this painting, particularly in the strong contrast between the dark, almost silhouetted figures and the luminous sky. It is hardly surprising that the ever-changing sky was a source of such fascination to a group of painters whose interest lay in the rendering of the quality of light and in the evocation of a fleeting image. This work is, in every way, characteristically Impressionist – it has spontaneity and immediacy, a lively use of colour, rapid almost nervous brushstrokes and truthfulness and accuracy with no hint of drama or sentimentality.

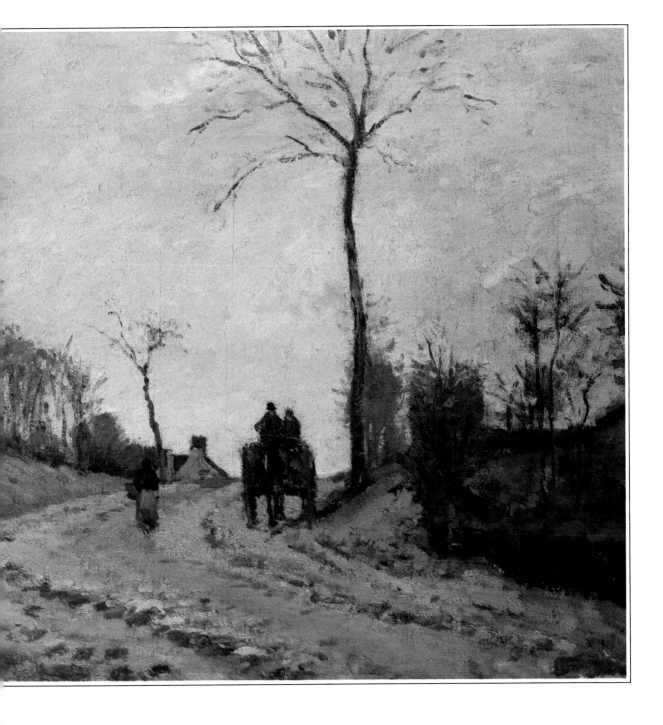

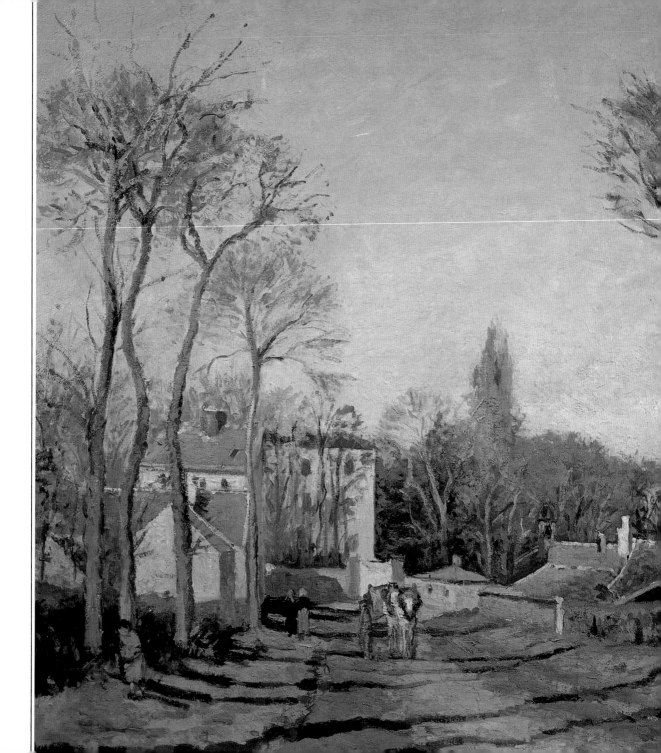

◁ **Entry to the Village of Voisins, Yvelines** 1872

Oil

IT IS INTERESTING to see how frequently Pissarro peopled his landscapes with figures. Unlike the other Impressionists, he did not see landscapes and portraits as separate and independent genres. Animals, working peasants, people chatting, women shopping, feature again and again – sometimes central to the scene, sometimes, as here, peripheral and appearing as if by chance. As a rule, Pissarro's landscapes lack grandeur; what they reflect is the artist's own humanity. There is a sense of natural harmony in this scene of peasants and countryside and a feeling of complete accord.

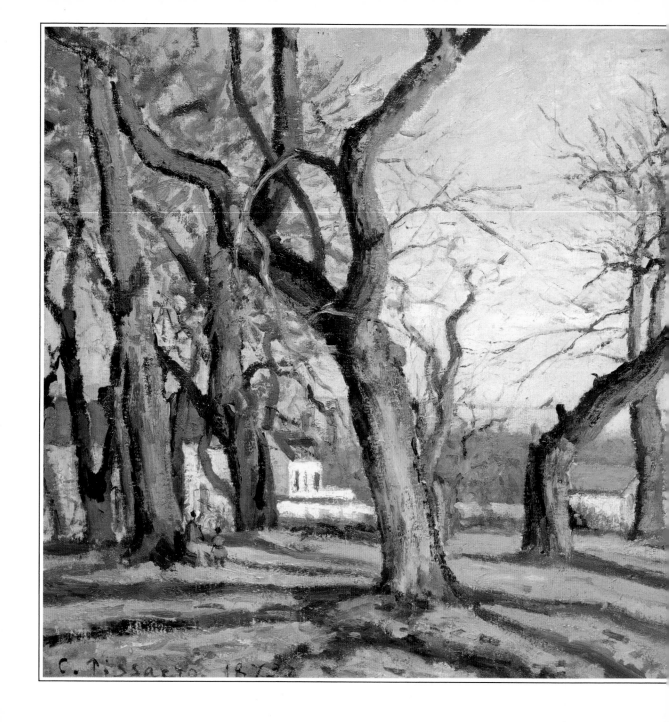

◁ **Chestnut Trees at Louveciennes** 1872

Oil

MANY OF PISSARRO'S landscapes have a quality of abstract design as a tracery of trees and branches form a graphic pattern across the canvas. Buildings are glimpsed between the trunks, light is diffused and interrupted, shadows are cast and the broken tree with its leaning trunk forms a dramatic counterpoint to the rhythm of the composition.

Vue de Pontoise 1873

Oil

▷ *Overleaf, see pages 26-27*

OSNY AND AUVERS were among the places Pissarro visited at this time. Cézanne was also working on landscapes in this region and the two artists undoubtedly influenced each other. In this painting of Pontoise, the town in the background is strongly reminiscent of the younger artist's style. Cézanne was committed to the idea of the unification of art and nature, gradually evolving a theory that all nature is comprised of three basic geometric shapes. Although he did not fully formulate this until after Pissarro's death, it is apparent in an embryonic form even in his early works. It is likely that the two men discussed their ideas and were familiar with each other's paintings. There is an unmistakable echo of Cézanne in the geometric composition of the houses, and also very slightly in the use of colour, but the scene is filtered through Pissarro's own vision, together with his love and knowledge of the region.

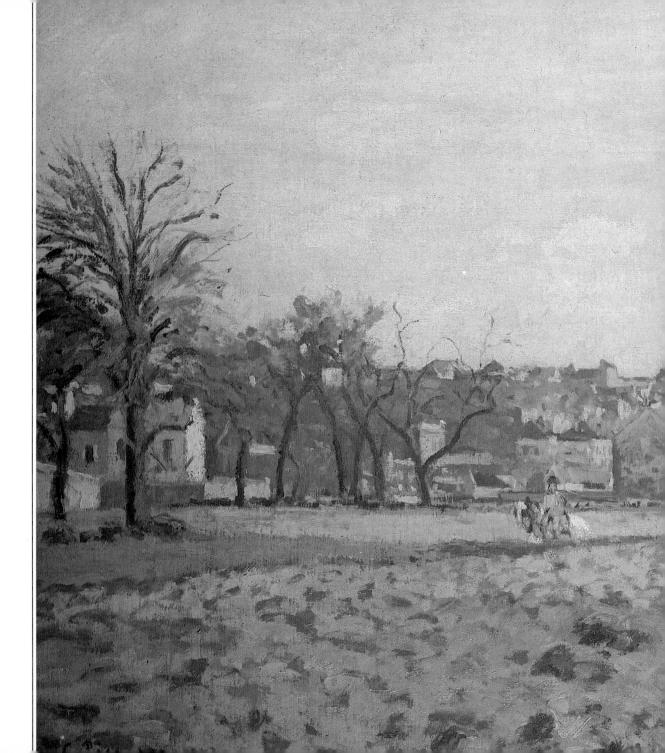

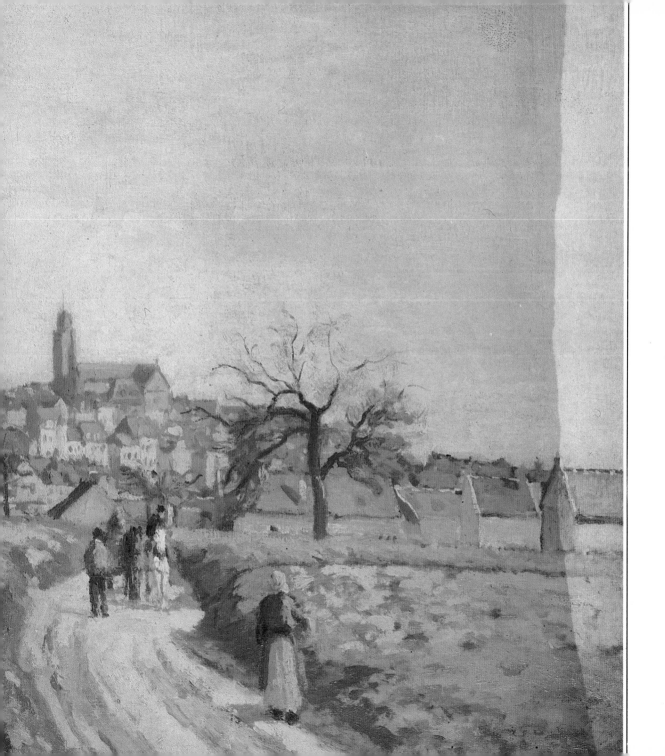

▷ **Hillside of l'Hermitage,
Pontoise** 1873

Oil

L'HERMITAGE was the quarter
of Pontoise where Pissarro
went to live on his return from
England following the Franco-
Prussian War. He had already
produced several fine
paintings of the surrounding
area, and both the village and
nearby countryside featured
prominently in his work over
the next few years. The fact
that he found inspiration in
familiar scenes indicates
neither boredom on his part
nor repetition in his work.
A profound observer of the
natural landscape, he
delighted in its many changing
facets, joyously capturing here
the way the sunlight falls on
the ancient, moss-grown brick
of the walls in contrast with the
neat raw freshness of the fields
behind and the carefully
cultivated beds in the
foreground.

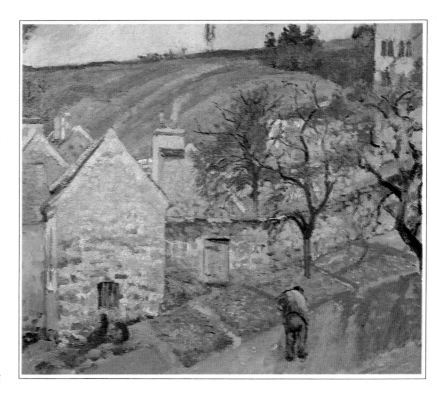

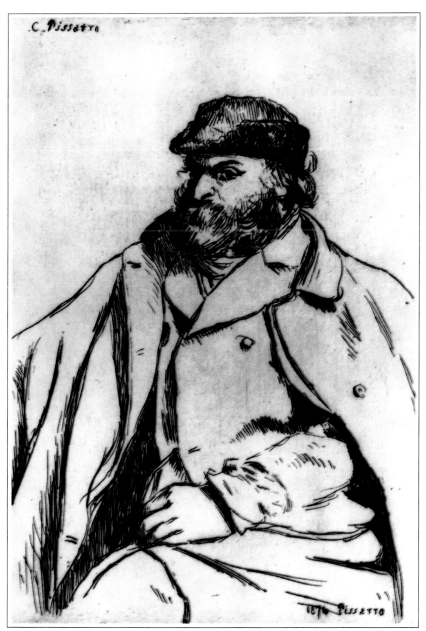

◁ **Portrait of Cézanne** 1874

Drawing

PISSARRO AND THE 35-year old Cézanne had been friends for some 12 – 13 years by the time this portrait was drawn. The works that Cézanne submitted for the notorious exhibition at the Boulevard des Capucines provoked harsher criticism than any, with the exception of Monet's *Impression: Rising Sun*. Such was the derision that one critic even called him 'a sort of madman'. Disappointment and anger are combined in this portrait and Pissarro also engagingly reveals his friend's extreme sensitivity. Even if we did not know the subject of the portrait, every line of the drawing describes a man of defensive self-sufficiency, considerable intellect, profound introspection and ferocious determination.

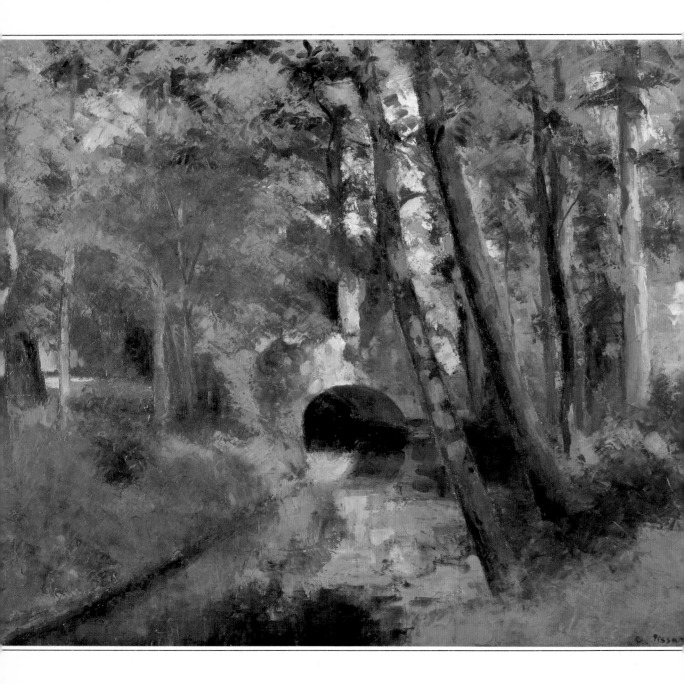

◁ **The Little Bridge, Pontoise** 1875

Oil

SUNLIGHT FILTERS through the foliage of close-growing trees and is reflected by the river in this superbly tranquil scene. The vibrant colour built up in a series of careful variations in tone captures the delicate nuances of nature. All is light and shade – no harsh lines intrude to disturb the clarity of the impression. The longer brushstrokes in dashes of brighter colour are reminiscent of Monet's work at this time. It is hardly surprising that virtually all the Impressionists were endlessly fascinated by the play of light on water.

Landscape, Pontoise 1875

Oil

▷ *Overleaf, see pages 32-33*

THE FIGURES in Pissarro's landscapes always seem to be a part of the countryside with an inevitability and rightness within the composition. Often almost insignificant, they are usually absorbed in some activity – sitting down, bending over, working, shopping, chatting or even with their backs to the viewer.

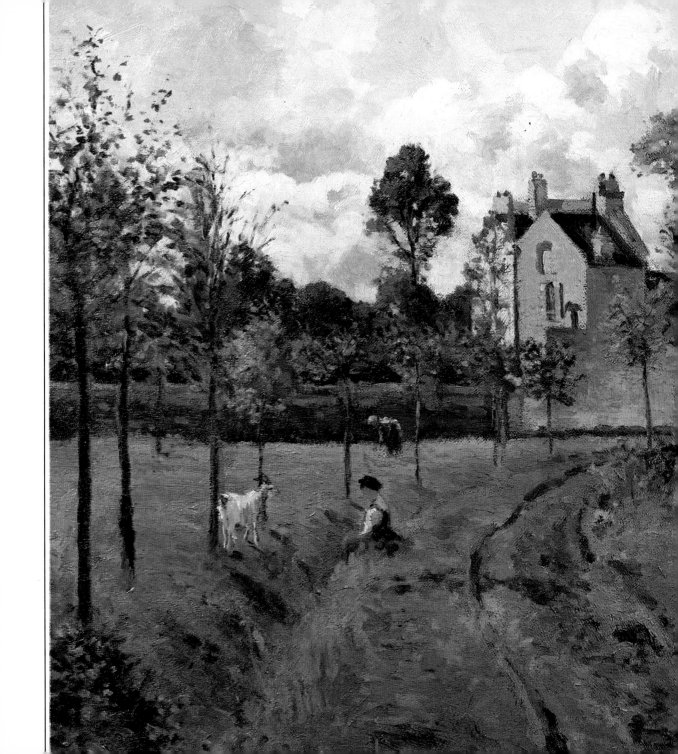

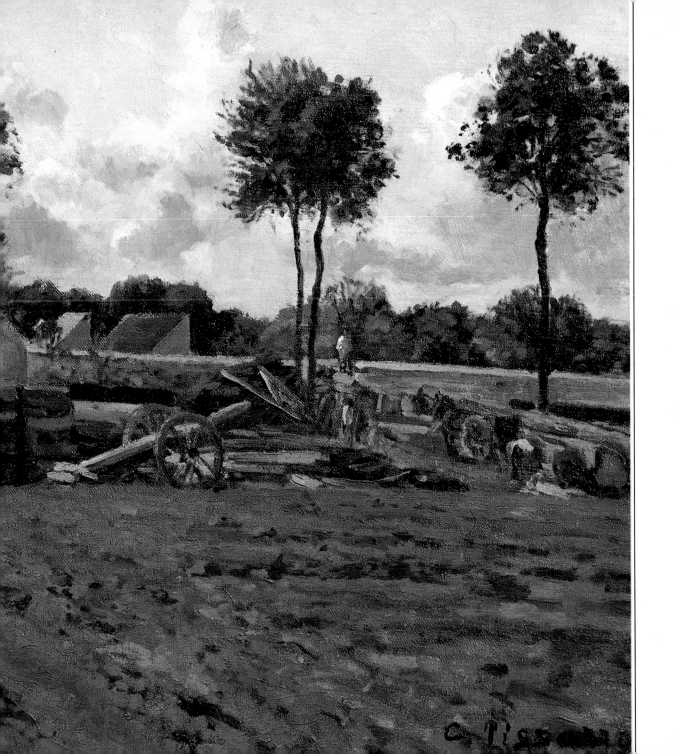

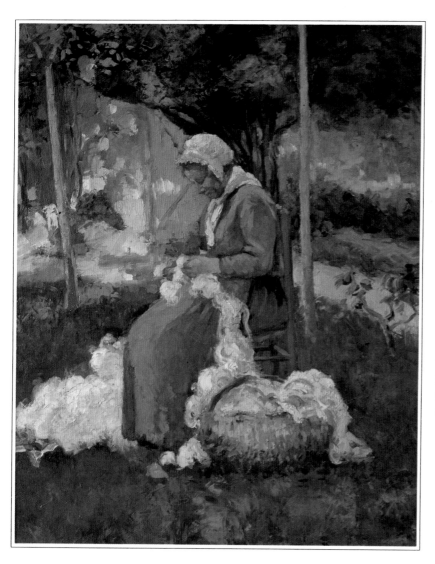

◁ **Female Peasant Carding Wool** 1875

Oil

UNLIKE MANY contemporary artists, Pissarro was never concerned with making a moral or narrative statement in his portraits. Rather, he chose to depict the commonplace things of life, but did so with warmth and sincerity. There is always a powerful sense of life, but, as here, the composition is often suffused with a mood of serenity. The woman in the painting is wholly absorbed in her work, at ease in her surroundings, competent and relaxed. Pissarro's world was never harsh, although it was often concerned with the austerity of everyday rural life.

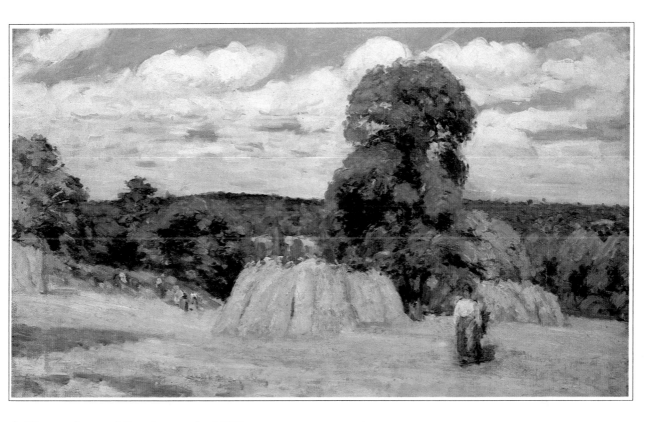

△ **Harvesting at Montfoucault** 1876

Oil

THIS WAS THE YEAR of the second Impressionist Exhibition. The first had resulted more from a general feeling of discontent with the establishment and conventional criticism, than from a consensus of artistic and aesthetic aims. Only those prepared to acknowledge the ignominious title 'Impressionist' exhibited this time and, in many ways, Pissarro stood out as their leader. His financial problems remained serious, although he was gathering a small and loyal following of collectors. Equally important, his work was gaining recognition and while the critics of Impressionism continued to raise their voices in scorn, its supporters were becoming more outspoken. Pissarro's work at this time is characterized by vibrant luminosity and a deep truthfulness in depicting what he saw.

▷ **Côte des Boeufs à l'Hermitage, Pontoise** 1877

Oil

HAVING EVOLVED a theory and technique of painting Pissarro was never content simply to reproduce more of the same. Throughout his life he remained experimental – sometimes successfully, sometimes not. With modest sales of his work and the beginnings of public recognition, he could be forgiven for relying on his growing reputation. Instead, he began to push the barriers further, seeking more ways of portraying on canvas the intangibility of light and capturing the moment and mood of what he constantly observed around him. The red-roofed houses, the wooded hillside, the preoccupied country people are the same here as in the *Vue de Pontoise* (pages 26-27) painted four years earlier; the sharp, almost nervous brushstrokes, the stippled technique and the subtle palette are not so much new as a further development of the vision towards which he had been striving for more than 10 years .

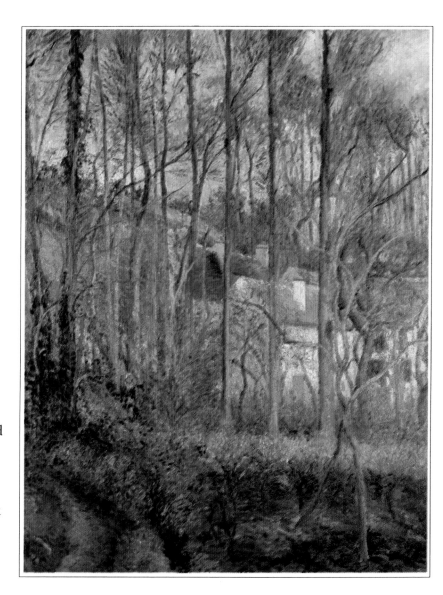

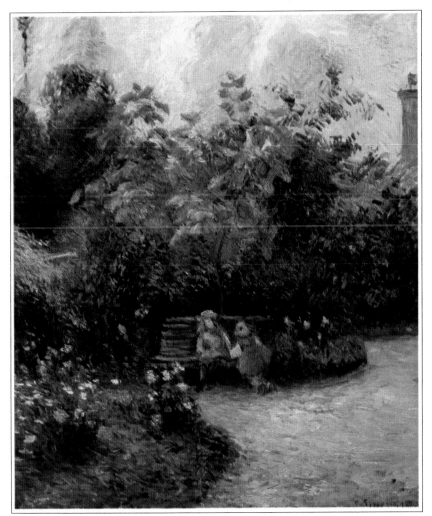

◁ **A Corner of the Garden at the Hermitage** 1877

Oil

THIS CHARMING SCENE is typical of the way that Pissarro painted children, a little like a modern-day photographer who tries to keep out of their line of vision and shoots while they are occupied with some other activity. The parallel, of course, is only partially valid for this is not merely an impartial record of the scene but the work of an artist. The two girls are immersed in their own activities and, as with *The Girl with a Stick* (page 44) painted some four years later, it is almost as though we have come upon them by chance. The people who populate Pissarro's landscapes always seem to be part of them, rather than imposed on their surroundings. The startling splash of colour in the flower-bed, echoed in the dress of the child with her back to us, is a masterly touch.

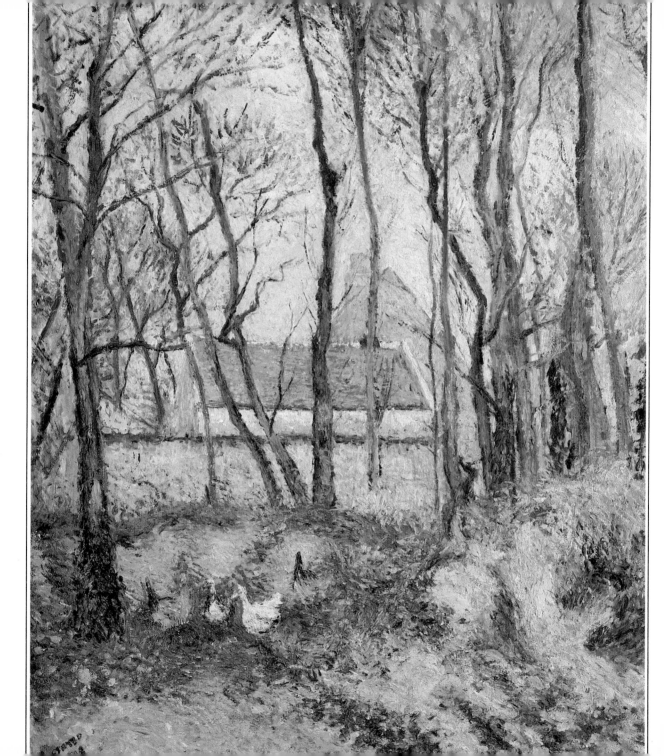

◁ **The Path of the Wretched**
1878

Oil

LIKE THE *Côtes des Boeufs à l'Hermitage* (page 36) of the previous year, this painting betrays a fascination with glimpses through a fine tracery of trees. Cézanne, too, at this time was painting similar landscapes. Indeed, Pissarro actually owned a painting by his friend of the Quai de Pothius where his own house was situated. However, where Cézanne was absorbed by the form of the trees themselves, Pissarro's interest extended to the entire scene and its mood of rural serenity. The colourful farmyard birds in the foreground could only have been painted by him.

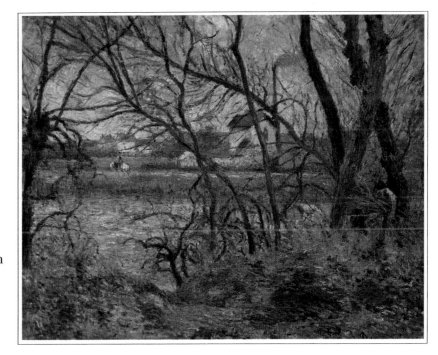

△ **The Banks of the Oise, near Pontoise** 1878

Oil

A FAMILIAR SCENE in cloudy weather presented a different challenge – an equally demanding encapsulation of light, mood and atmosphere. The metallic quality and strange luminescence of the sky, the writhing forms of the leafless trees, the disturbed, broken surface of the river and even the understated struggle of the man collecting kindling create a mood of something slightly foreboding, and a sense of nature poised to unveil a less kind and sympathetic face. Pissarro rarely, if at all, allowed his personal sorrows or worries to intrude on his work and this was not the hardest year that he had recently faced. The bleak mood of this painting is in the landscape rather than in the painter.

▷ **Vegetable Garden at the Hermitage, Pontoise** 1879

Oil

ONE OF THE MANY criticisms levelled against Impressionism was that it lacked form and proper structure. While this painting is undeniably Impressionist in style and technique, no such failing can be ascribed to it. The composition draws the eye further in to focus on the detail and the perspective is precise and accurate.

Once again, the scene is commonplace, the gardeners wholly absorbed in their work, but the mood is one of burgeoning growth. The many shades of green are applied with Pissarro's favourite stippling technique, with the result that the lush foliage seems to have been shaken gently by an unseen summer breeze.

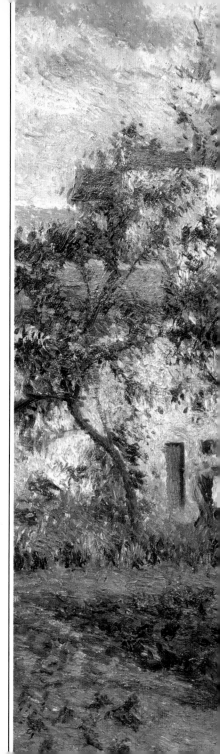

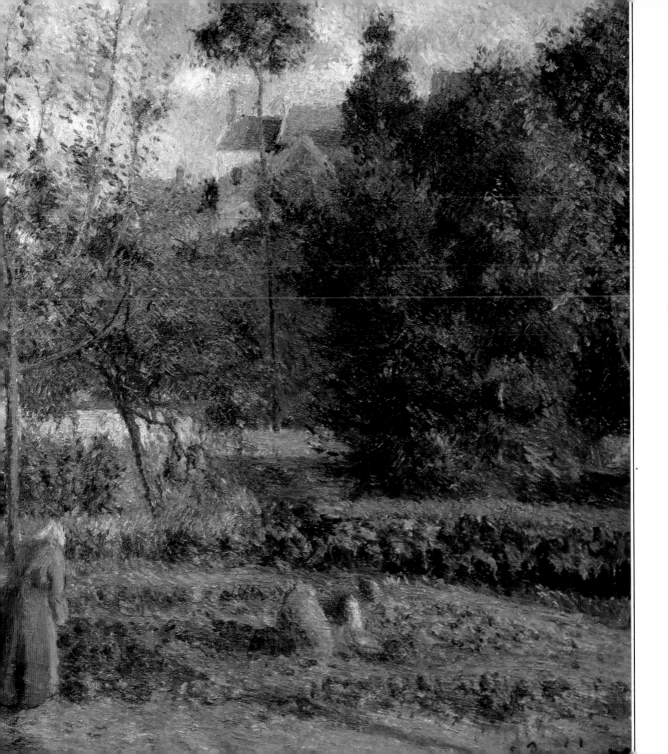

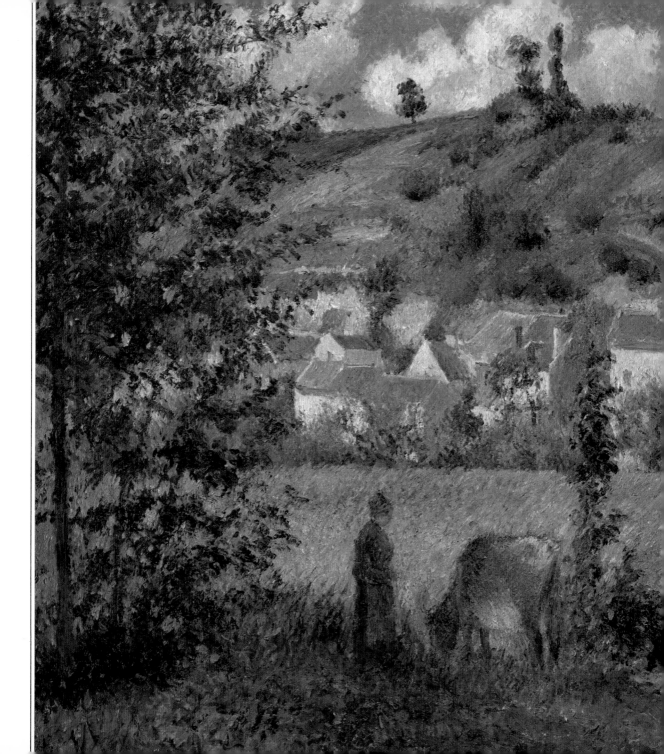

◁ **Landscape at Chaponval** 1880

Oil

THIS PAINTING is an indication of the direction in which Pissarro was to move – and from which he was later to retreat – during the 1880s. The brushwork has a new quality that is a precursor of his *Pointillist* phase. Pissarro may have been regarded as the 'elder statesman' of the loose group of artists who formed the Impressionists, but his technique was never rigid nor were his ideas about painting fixed. He was fascinated by new ways and eagerly embraced innovation, both in his own work and in that of others.

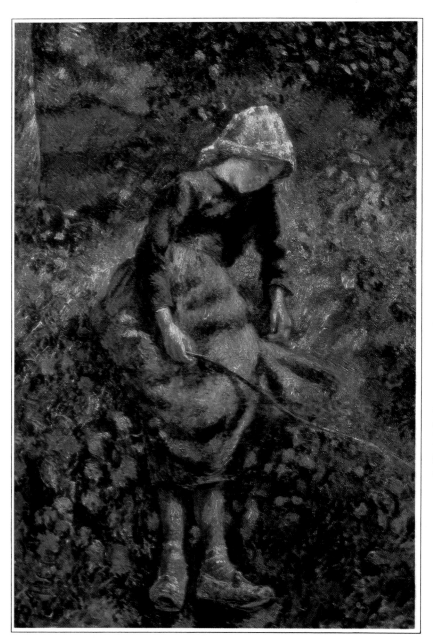

◁ **Girl with a Stick** 1881

Oil

THIS BEAUTIFULLY observed study of a child lost in thought is a deceptively simple composition. Pissarro himself, when giving advice to a younger artist, wrote, 'You should paint the essence of things'. Here he has precisely captured the essence of daydreaming and the essence of girlhood. The casual pose, head resting on her shoulder, eyes unfocused and the hand loosely grasping the stick, is enhanced by the dense, leafy background of the quiet nook where the unnamed girl has casually concealed herself. We feel as if we have come upon this child by chance. She is so completely absorbed in her own thoughts that the viewer has not disturbed her; we may steal away and leave her to her dreams.

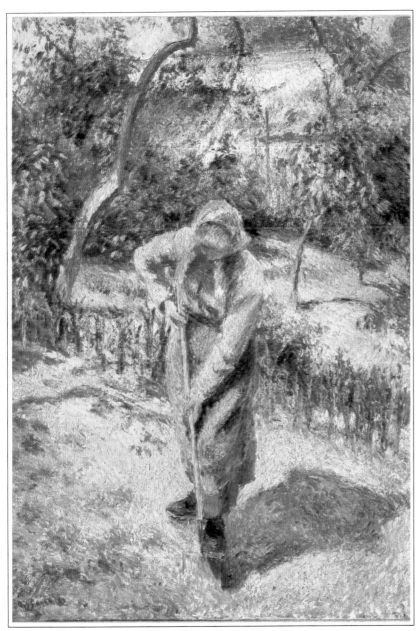

◁ **Woman Digging in an Orchard** 1882

Oil

THIS WAS THE YEAR of the seventh Impressionist Exhibition and the artists who participated, including Pissarro, Renoir, Monet and Sisley, were at last achieving a level of recognition. After the previous exhibition, Huysmans, a long-time admirer of Impressionism, had written, 'One fact is dominant, the blossoming of Impressionist art which has reached maturity with Pissarro'. Acceptance, let alone approval, was not universal, however. Durand-Ruel exhibited a number of Impressionist works in London during this year. William Holman Hunt, the Pre-Raphaelite painter, was horrified by what he saw and said that he wished to 'warn the world that the threat to modern art, meaning nothing less than its extinction, is Impressionism'. Looking at this delightful study of a peasant at work, such ferocious criticism is hard to comprehend.

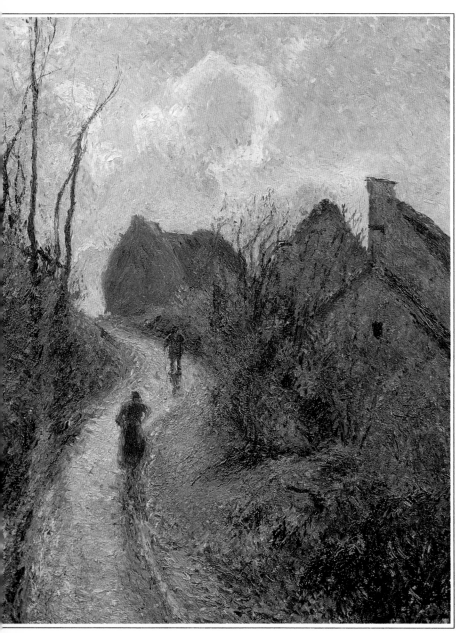

◁ **Road Climbing to Osny**
1883

Oil

THE TWO FIGURES are barely delineated, yet there is an unmistakable sense of effort as they toil along the steep pathway. This is a mature work which, nevertheless, still has a freshness and immediacy, evoking what has often been called the 'fleeting moment'. The purity of the colour, the radiance which illuminates the entire painting, the accuracy of his observation of nature and the sureness of touch all proclaim Pissarro's mastery.

▷ **Pork Butcher** 1883

Oil

PISSARRO PAINTED a number of scenes of markets, precisely capturing the feeling of busy, but organized activity, the colour and the atmosphere. He was never bored with the mundane, but depicted ordinary people and the minutiae of everyday life with affection. Unlike some other artists, he never sentimentalized humble people; rather, his work emanates a feeling of goodwill and fidelity to the truth.

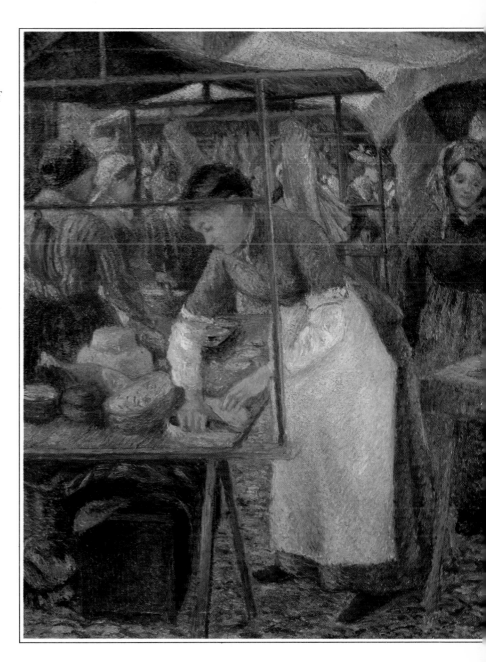

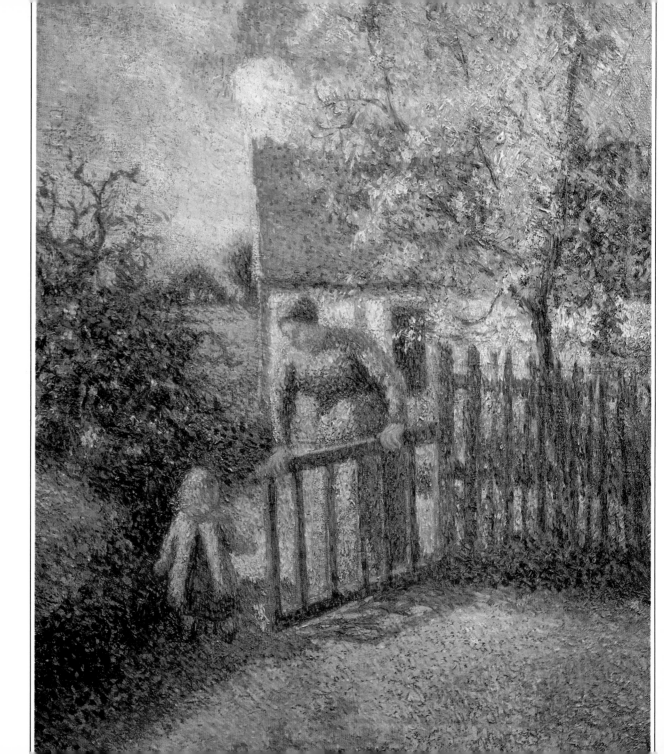

◁ **Mother and Child in a Garden** 1886

Oil

PISSARRO WAS INTRODUCED to Seurat in 1885 and soon became an enthusiastic advocate of Pointillism and an almost overnight convert to the younger man's colour theories. This technique of painting colour in a multitude of dots involved detailed preparation and many preliminary sketches, as well as long hours in the studio applying the paint. This is the complete opposite of the way Pissarro had previously worked and his adoption of this style both surprised and dismayed many of his admirers, particularly Durand-Ruel, the dealer who had done much to further the careers of the Impressionists. It is not really surprising, however, that an artist, who had spent some 20 or more years exploring and experimenting with ways of capturing the clarity, luminescence and vibrancy of light, should have been prepared to commit himself wholeheartedly to a new approach.

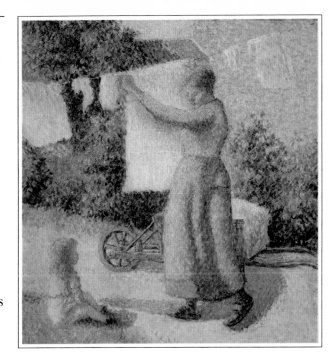

△ **Woman Hanging up the Washing** 1887

Oil

LOOKING at this painting, we still have a sense of having caught a secret glimpse of someone's private life, the woman and the child captured in a moment of conversation. However, there is not quite the same charm or spontaneity as there is in some earlier works. Perhaps Pissarro's adherence to so-called scientific Impressionism, as opposed to romantic Impressionism, is what gives this work a laborious feel. About two years later, he was to write to his son Lucien, 'I have not yet been able to solve the problem of achieving pure tone without any harshness – to determine what can be done to retain the qualities of purity and simplicity of the Pointillists and yet not lose the breadth, suppleness, freedom, spontaneity and freshness of expression of the Impressionists.'

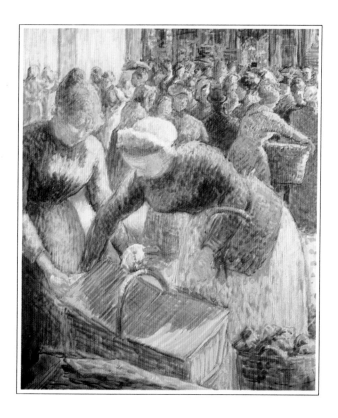

△ **The Market at Pontoise** 1887

Oil

PISSARRO PAINTED market scenes on several occasions and this painting has the colour and vitality that typify his work. Although painted at a time when he was still deeply involved and influenced by what was later to be called Neo-Impressionism and with Seurat's pointillist technique, this painting has more in common with the works of his fellow Impressionists, with echoes particularly of Renoir, Degas and Gauguin.

▷ **Apple Pickers, Eragny** 1888

Oil

WHILE WARM AND SINCERE in his enthusiasms, Pissarro never ceased to question theories and techniques. Towards the end of this decade, he began to have severe misgivings about the direction his art had taken, but was unwilling to abandon the path without proper thought and reflection. Some critics have accused him of vacillation and indecisiveness, and many have suggested that he was too heavily influenced by the work of other painters. This does him an injustice, for Pissarro was never the slave of expediency, in spite of heavy financial worries, and those who knew him had no doubts about his artistic integrity. He wrote to his son Lucien in September of this year, 'For the dot is thin, without consistency, transparent, monotonous rather than simple . . .' Certainly, this painting lacks depth and Pissarro's extraordinary ability to make us feel that we can touch the intangible is completely absent.

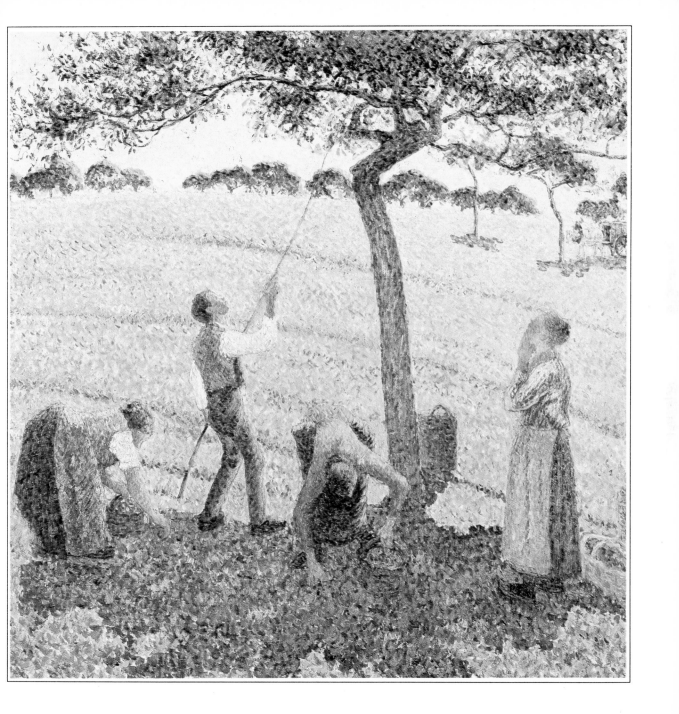

▷ **Pruniers en Fleurs** 1889

Oil

BY THE END OF the decade, Pissarro was seeking a way back to his former, more immediate approach to painting. This work represents a kind of transitional period before he completely abandoned his *Pointillist* experiments and harks back to his earlier Impressionist technique. About this time, he wrote, 'I am looking for a way to replace the use of dots; up until now, I have not found the technique I am looking for.

The execution of my work is not rapid enough, in my opinion, and there is not the instantaneous reaction of the senses which I consider vital.' Indeed, he had not found what he was looking for. There is certainly something less pedestrian and laborious here, but nevertheless, there is still a strong element of his forcing himself to obey an artificial 'science' of colour. The painting is a signpost to the past rather than to the future.

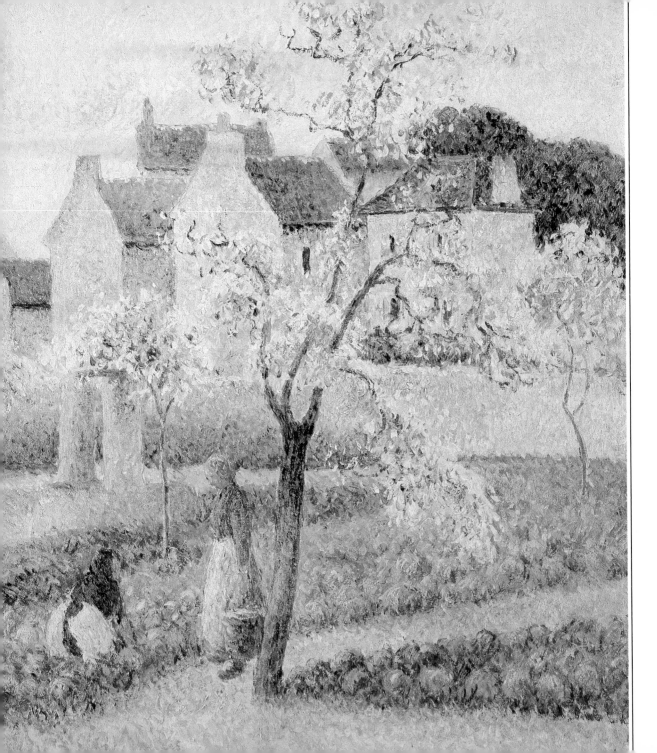

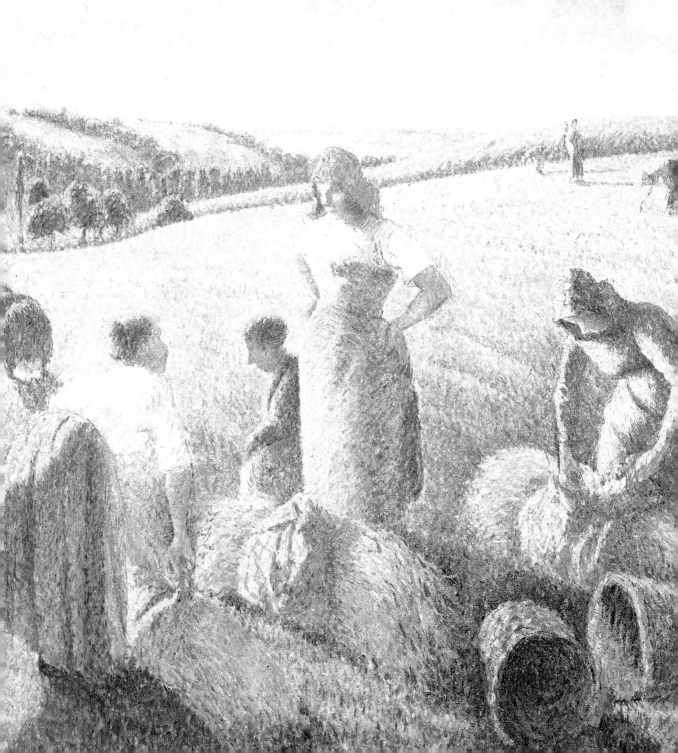

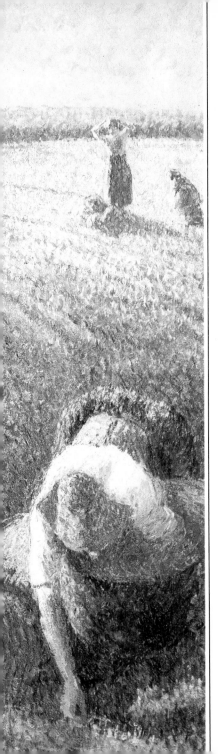

◁ **Women Haymaking** 1889

Oil

AT LEAST PART of the appeal of the *Pointillist* technique was its effectiveness in capturing the effects of bright sunlight. Here, in one of Pissarro's last paintings rendered in this manner, there is a very powerful feeling of both light and heat – the glare of the sunlight reflected off the stubble, the women's backs bent as they work and the clear sky all combining to create the mood. The composition, too, is interesting, with its sharp focus on the figures clustered informally in the foreground and a sense of great expanse as the field slopes away and the eye drifts towards the far horizon.

▷ **Cours La Reine, Rouen**
1890

Oil

NOW 60 YEARS OLD, Pissarro
once again made a dramatic
change in his style of painting.
Much of the style of his earlier
years was rediscovered, but
modified, with a new sureness
and a revised palette. During
this decade, he travelled
around France again, visiting
Rouen, Le Havre and
Burgundy, where he found
new inspiration in urban
scenes and cityscapes. As
always, it is the quality of light
that fascinates, whether
filtered through the foliage of
the trees, reflected off the
surface of the water or muted
by the clouds in the sky.

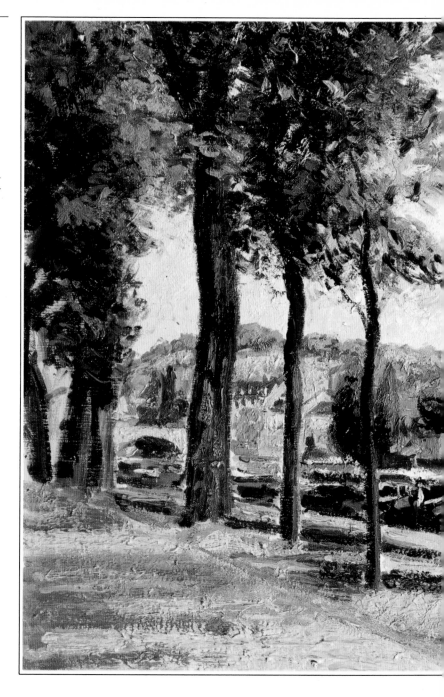

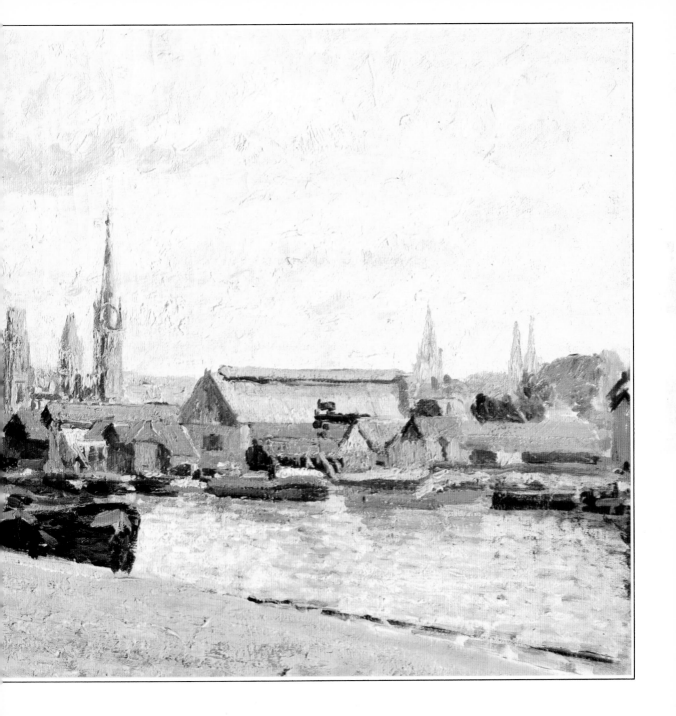

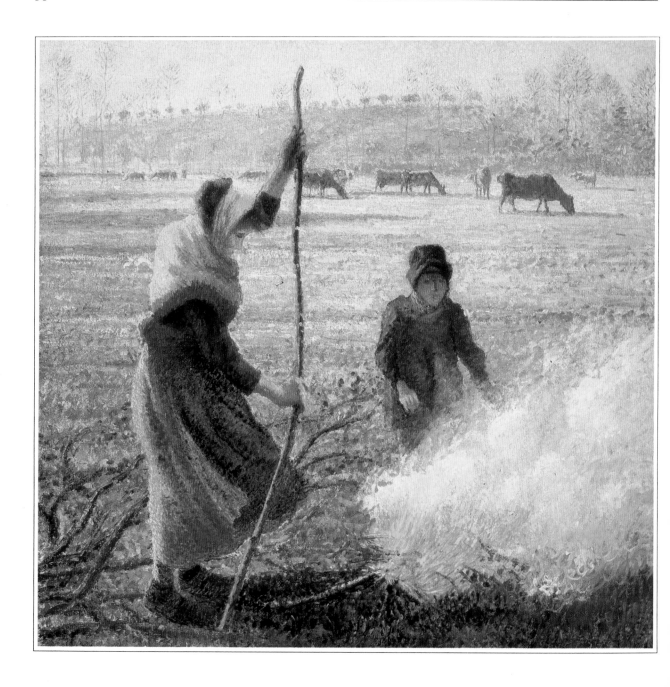

◁ **White Frost, Woman Breaking Wood** 1890

Oil

RENOIR IS REPUTED to have said, 'Movement can be as eternal as immobility so long as it is in harmony with nature'. He could very easily have been speaking of this painting. The cattle grazing calmly in the background contrast with the activity of the woman, momentarily frozen in time, her skirt whipped up by the wind, her muscles tense with effort and hunched against the cold. The smoke billows, partially obscuring the child, and the whole scene is suffused with the pale light of winter.

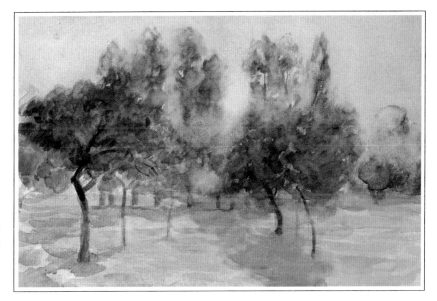

△ **An Orchard** 1890

Watercolour

THE WONDERFULLY subtle tones of Pissarro's watercolour palette superbly evoke the end of summer and the start of autumn. Painted almost entirely in patches of colour and with little line, this work demonstrates how Pissarro was honing his technique to the absolute essentials.

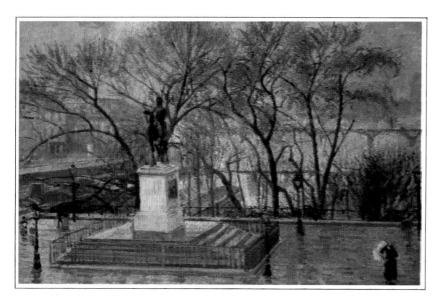

△ **Pont Neuf, Paris** 1892

Oil

PISSARRO TRAVELLED frequently to Paris from Eragny, where he had lived since 1884 and which provided a tranquil and safe haven for his entire family. Usually, these visits, which lasted several days, were prompted by dire financial need and Pissarro would spend much of his time visiting prospective buyers.

Nevertheless, he also found time to do some work and this is one of his most atmospheric paintings of the city. The looming, moody sky, the tracery of bare-branched trees and the wintry light reflected off the surface of the river and the wet cobbles have all the authority of this master of Impressionism.

▷ **The Flood at Eragny** 1893

Oil

IN THE FINAL YEARS of his life, Pissarro often executed his paintings from behind a window, particularly when he was staying in Paris and other cities in France. Perhaps he did the same, too, when he was at home at Eragny and certainly this flooded scene has a quality that suggests this. There is a strange and paradoxical mixture of moods – a tranquillity that belies the uncontrollable power of nature. At first sight, this seems a calm winter landscape, with leaning bare trees reflected in still water. It is only on closer inspection that its full import becomes clear – similar to the way that a window protects from the very reality that we view through it.

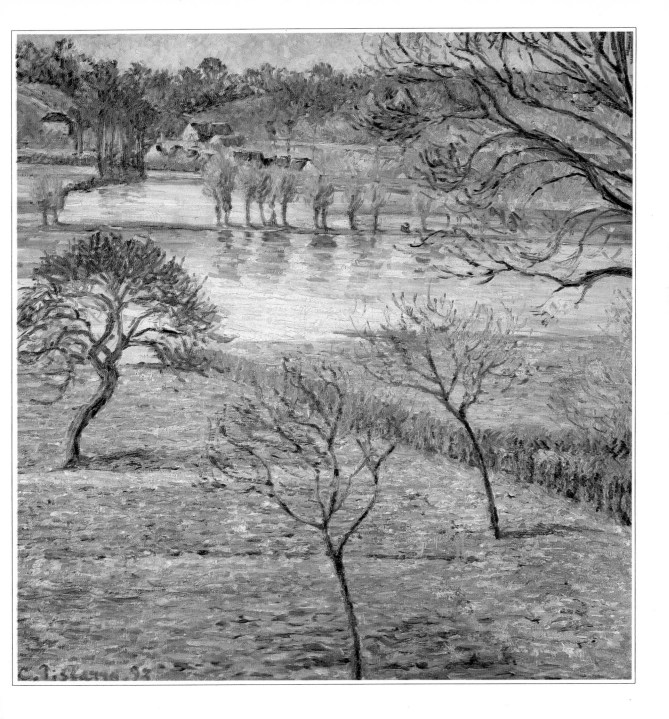

▷ **Countryside and Eragny, Church and Farm** 1895

Oil

HARDLY SURPRISINGLY, the glorious colours and wonderful luminescence of sunrise and sunset fascinated the Impressionists, perhaps Monet most of all. Pissarro also painted many familiar landscapes and, at this time urban scenes, too, in different lights at various times of day. In this work, he captures the magical light of the sunset sky – almost a case of art imitating life imitating art. The long shadows, the sinking sun, the little village nestling among the trees, the peacefully grazing cows in the foreground, the old stone of the buildings behind combine in an image of quite staggering beauty.

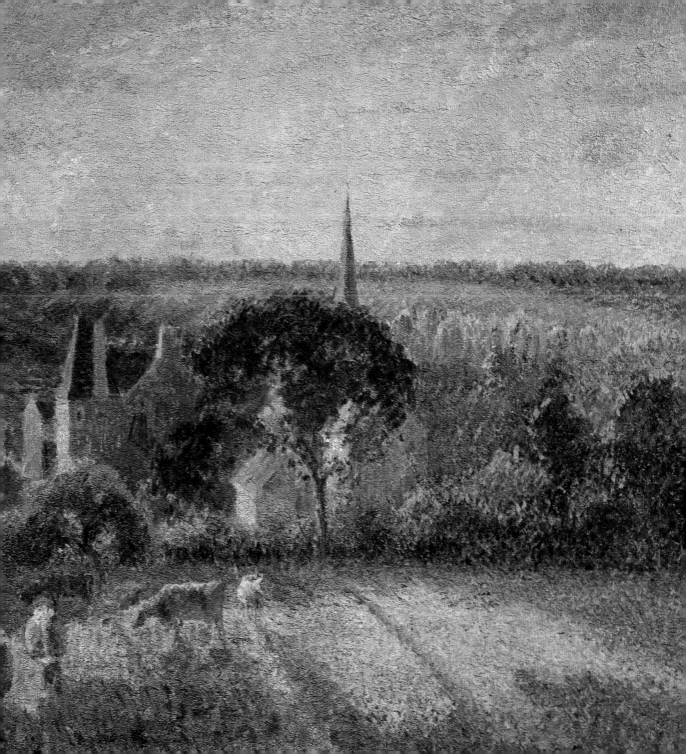

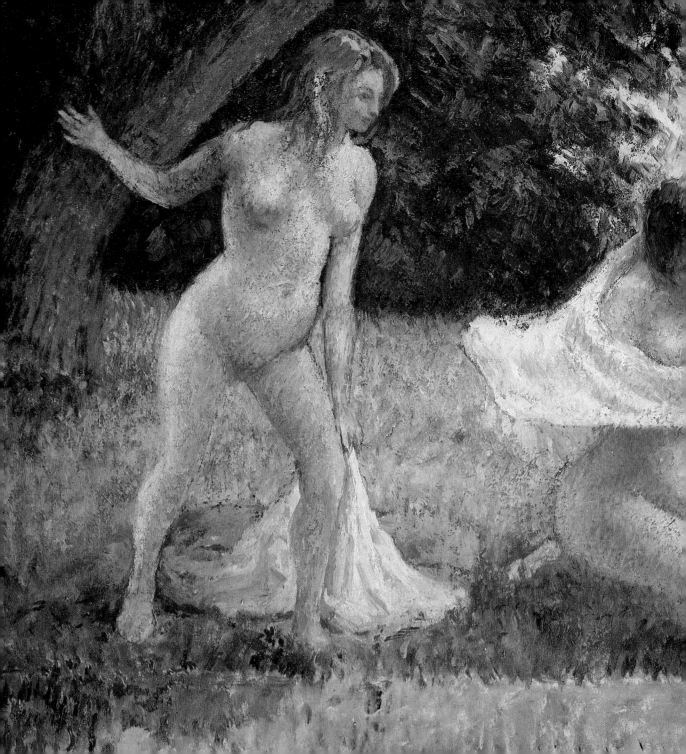

◁ **Les Baigneuses** 1895

Oil

PISSARRO RARELY PAINTED nudes, probably because they were not a natural feature of the French countryside. However, in this year he worked on both etchings and oil paintings of female nudes bathing. Strangely – perhaps through lack of practice – the skin tones lack the luminosity that we associate with Pissarro. The composition, too, does not demonstrate his usual confidence. The figures seem intrusive rather than inevitable and the pose of the woman on the left, particularly her awkwardly extended arm, is unnatural.

▷ **Great Bridge, Rouen** 1896

Oil

PISSARRO TREATED urban scenes in the same way as he approached those of the countryside. The cityscape, with its machinery, factories, houses, crowds and, in this case, boats and barges, is seen in terms of how the light is reflected, diffused, broken up and absorbed and how colours mingle, change and affect each other in just the same way as in a landscape with trees, cottages, animals and peasants at work. His perennial fascination with water probably drew him to this view, which he has depicted with vivid clarity and immense vitality. We can almost hear the busy bustling crowds and smell the smoke pouring upwards into the blustery sky.

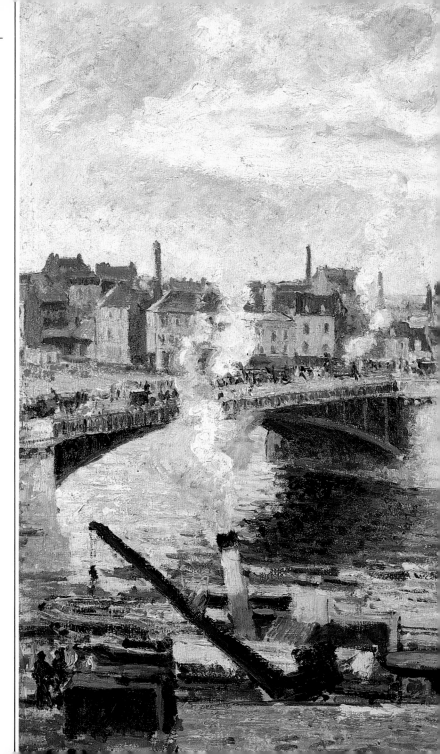

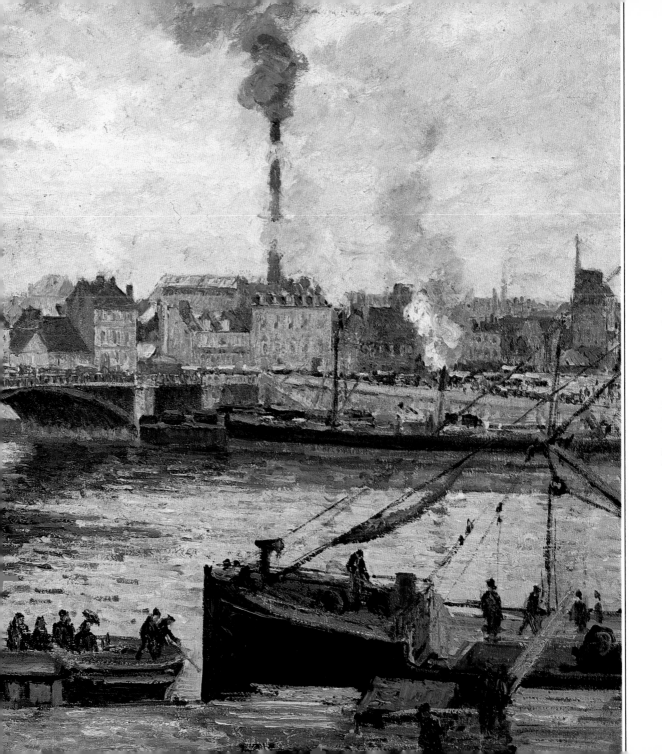

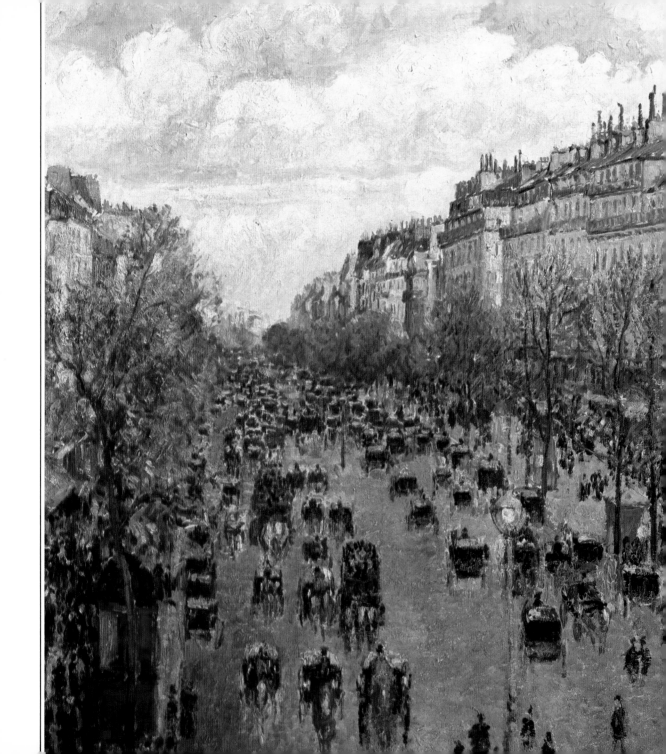

◁ **Boulevard Montmartre, Afternoon Sun** 1897

Oil

PISSARRO RETURNED time and again to paint familiar scenes, but not quite in the same way as Monet was doing at this time, creating a more or less formal series of studies of changing light. Pissarro was, indeed, fascinated by the way scenes changed at different times of day and of year, but his work is informed by a humanity and warmth uniquely his own. Just as he produced many paintings of Pontoise, La Varenne and Montmorency in the 1870s, and of Eragny in the 1880s, so he captured the many faces of Paris in the 1890s. The figures and vehicles are painted in a truly Impressionistic manner that powerfully evokes a strong sense of movement.

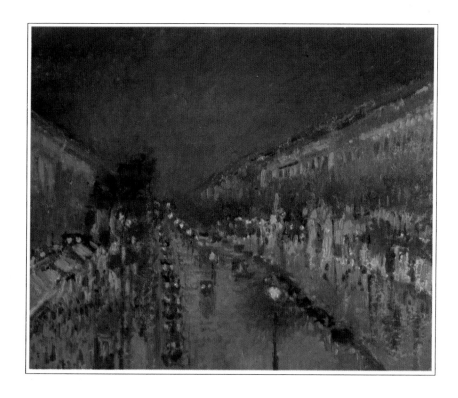

△ **Boulevard Montmartre at Night** 1897

Oil

AN EXERCISE IN THE subtle use of colour and pure depiction of light, this is probably the most Impressionist of all Pissarro's paintings. The lights are superbly reflected by the wet street and the scurrying figures are scarcely delineated.

▽ **Sunrise at Rouen** 1898

Oil

THE LIGHT AT that moment just as the sun rises has a strange colourless quality and a feeling of unreality. Paradoxically, it almost seems like an opacity rather than an illumination and it is probably far more difficult to capture in paint than the more glamorous pyrotechnics of sunset. This view of Rouen conveys precisely that prolonged breath-holding moment that starts the day, when night reluctantly releases its grip on the world but the sun is not yet master. By this time in his life, Pissarro's eyesight was failing, yet he never lost the clarity of his painterly vision. Ironically, perhaps this deterioration caused him to return more truly to the refined essence of Impressionism.

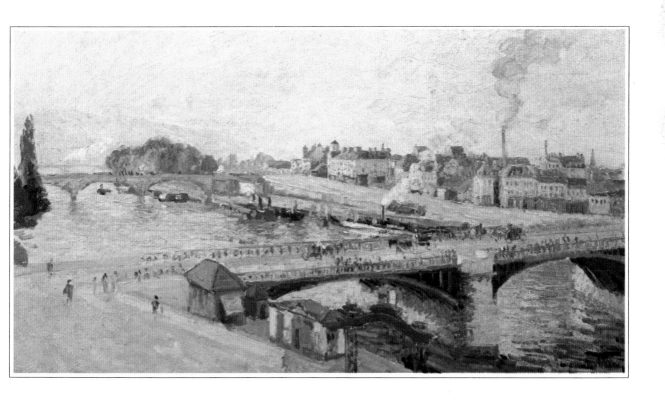

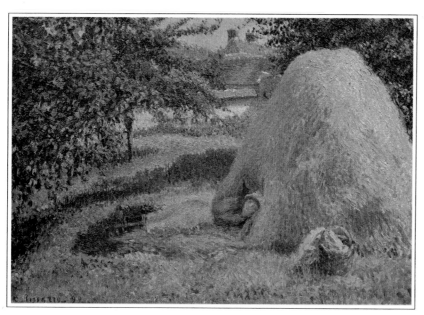

◁ **The Siesta** 1899

Oil

THERE IS A wonderfully languorous feel to this work. It is illuminated with the golden glow of warm sunshine. The woman has abandoned herself to sleep and we can almost feel the softness of the hay where she is lying. No other artist has ever captured so succinctly or portrayed so sympathetically the private moments of ordinary life.

▷ **Landscape with Cottage Roofs** 1899

Oil

REMINISCENT of some of his paintings of Louveciennes in the 1870s, this picture has all the hallmarks of vintage Pissarro but it is painted with the authority of the mature artist. The rural scene, the vibrant colour, the glimpses of other features caught through the trees and his favourite stippled technique are characteristic.

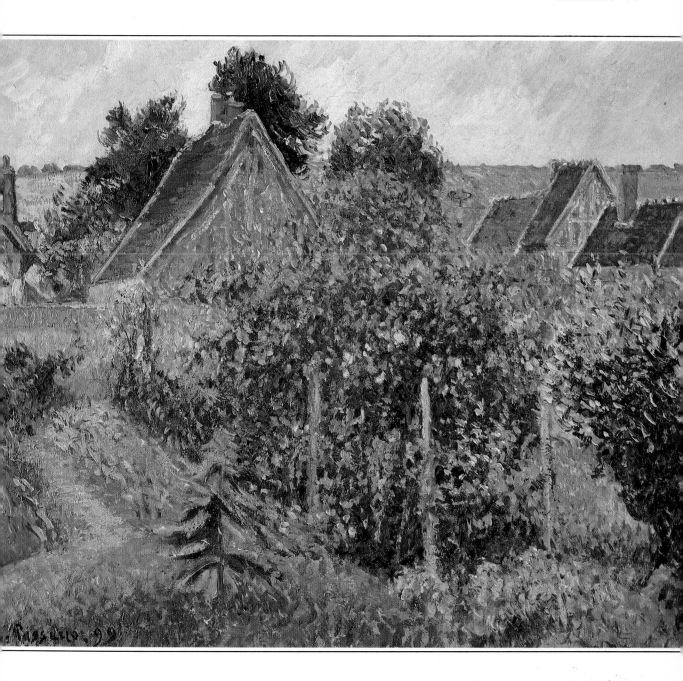

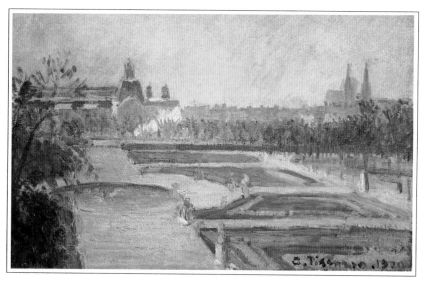

△ **The Tuileries and the Louvre** 1900

Oil

THIS IS ANOTHER of Pissarro's Paris paintings, of a scene observed through a window. His Impressionistic style had, by this time, become increasingly refined. His work was at last being recognized and his reputation was considerable. Durand-Ruel had welcomed him 'back' after his digression into Pointillism and a growing number of collectors had been buying his works throughout the decade. Regular exhibitions ensured that his paintings remained in the public eye and, while his financial problems never entirely went away, he and his family were much more secure.

▷ **Portal of the Church of St Jacques, Dieppe** 1901

Oil

PISSARRO PAINTED this church from different viewpoints in 1901. In this atmospheric work, golden afternoon sunlight suffuses the scene, illuminating the venerable darkened stone of the building. It was unusual for Pissarro to create a composition where a single building – let alone, only part of a single building – occupies most of the canvas. It is through this that he achieves a sense of the massiveness and weight of his subject, both physically and spiritually.

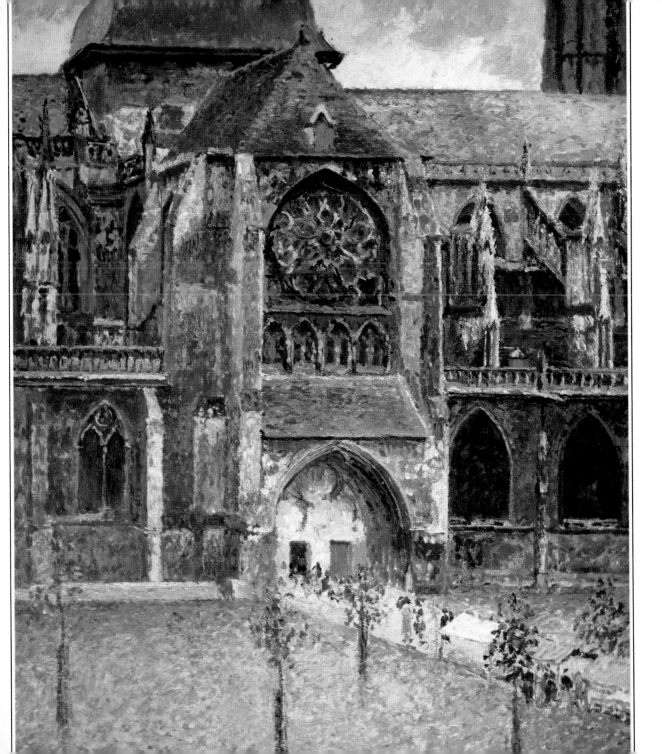

▷ **The Pilot's Jetty, Le Havre** 1903

PISSARRO'S FRIEND and fellow Impressionist, Claude Monet, spent his childhood years in Le Havre and always maintained that his sense of light derived from living close to the sea. Looking at this marvellous morning sky and the broken light on the choppy water in Pissarro's evocative depiction of the jetty, it is easy to understand Monet's feelings. It is hard to repress a shiver as we view the crowded quay from which, it seems, the morning fog has only just rolled away.

Another of Pissarro's friends, Paul Gauguin, wrote of the older man, 'If we observe the tonality of Pissarro's work, we find there, despite fluctuations, not only an extreme artistic will, never belied, but also an essentially intuitive pure-bred art'. Gauguin freely acknowledged his debt to Pissarro and admired him as pre-eminently the leader of the Impressionistic movement. A painting such as this witnesses the truth of Gauguin's statement.

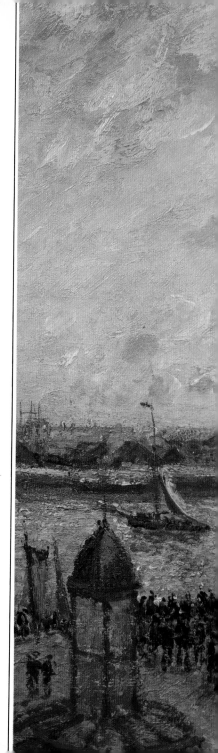

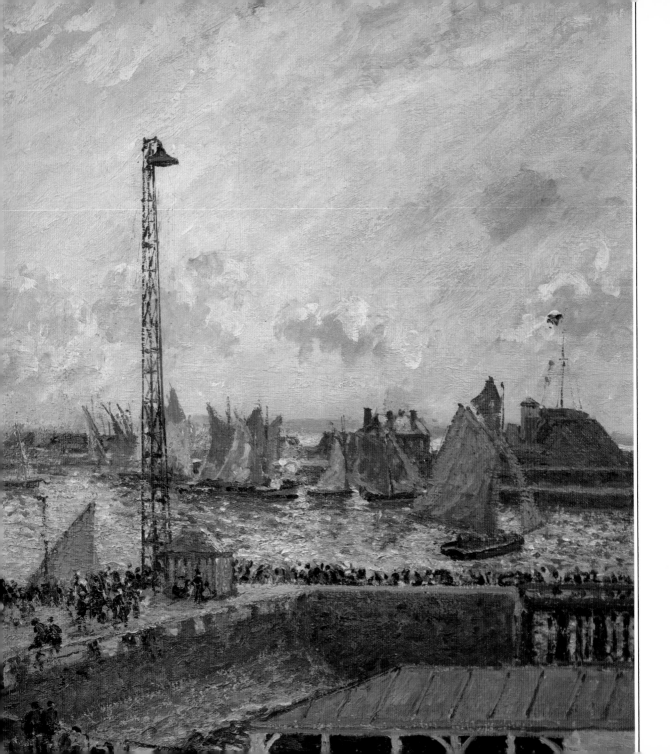

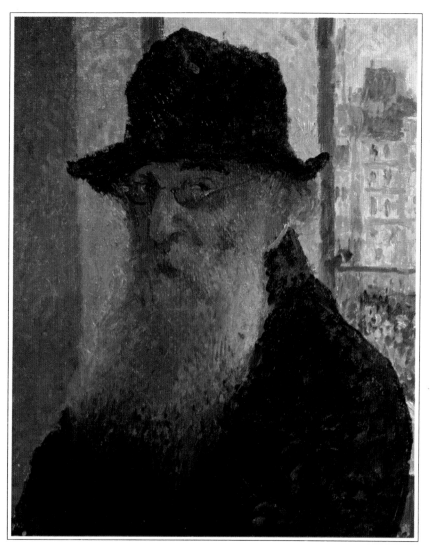

◁ **Self-portrait** 1903

Oil

A STRAIGHTFORWARD portrait was an unusual subject for Pissarro who never believed that landscape painting and portraiture were separate genres. However, he had both painted and drawn his children when they were young, and made an etched self-portrait in about 1890. This self-portrait was painted in the year of his death, when he was aged 73. This gentle-looking, wise and unassuming figure was a giant of his age and this delightful painting is, perhaps, the most fitting epitaph. Appropriate, too, are the words written by Théodore Duret after Pissarro's death: 'Pissarro was good-natured in character and calm in temperament. Life built up a great fund of philosophy in him. He endured the years of misery and disappointment with serenity, and when success came and he was able to have the good things in life, he changed none of his ways, and never sought the honours, decorations and recompense which, in the eyes of most artists, appear to be the most precious things to receive.'

ACKNOWLEDGEMENTS

The Publisher would like to thank the following for their kind permission to reproduce the paintings in this book:

Bridgeman Art Library, London/Art Institute of Chicago 14; /**British Museum, London** 59; /**Carnegie Institute, Pittsburgh, Pennsylvania** 66-67; /**Christie's, London** 14, 18-19, 20-21, 26-27, 38, 52-53, 56-57, 61, 64-65, 71, 74; /**Collection Durand-Ruel, Paris** 48, 72; /**Dallas Museum of Fine Arts, Texas** 51; /**Dr. H.C.E. Dreyfus Foundation, Kunstmuseum, Basle** 44-45; /**Giraudon/Musée des Beaux-Arts, Valenciennes** 46; /**Giraudon/Musée d'Orsay, Paris** 10-11, 16-17, 22-23, 28, 32-33, 35, 37, 39, 40-41, 62-63; /**Hermitage, St Petersburg** 68-69; /**Lauros-Giraudon/Musée d'Orsay, Paris** 12-13; /**Mayor Gallery, London** 73; /**Musée Bonnat, Bayonne** 29; /**Musée d'Orsay, Paris** 47, 42-43, 44; /**Museum of Fine Arts, Boston MA** 50; /**National Gallery, London** 36, 70; /**National Gallery of Scotland, Edinburgh** 9; /**Palais de Tokyo, Paris** 49; /**Private Collection** 24-25, 45, 60, cover; /**Sammlung Buhrle** 34; /**Stadtische Kunsthalle, Mannheim** 30; /**Tate Gallery, London** 47, 76-77, 78.